Casual Coloring 4

David Wilkins

©2016 David Wilkins

First Publishing 2016

ISBN- 13: 978-1535541022

ISBN- 10: 1535541024

In Casual Coloring 4 you will find more ways to express yourself through color. Allow your mind to drift from the daily cares of life. Let your subconscious choose the selection of colors to fill the designs in a meaningful manner for you.

Many times in Life were are not in control of the circumstances around us and this simple pleasure coloring allows you to take control of the page, colors, medium used to fill in the pages. This allows you to take some control in your life (I love my therapist).

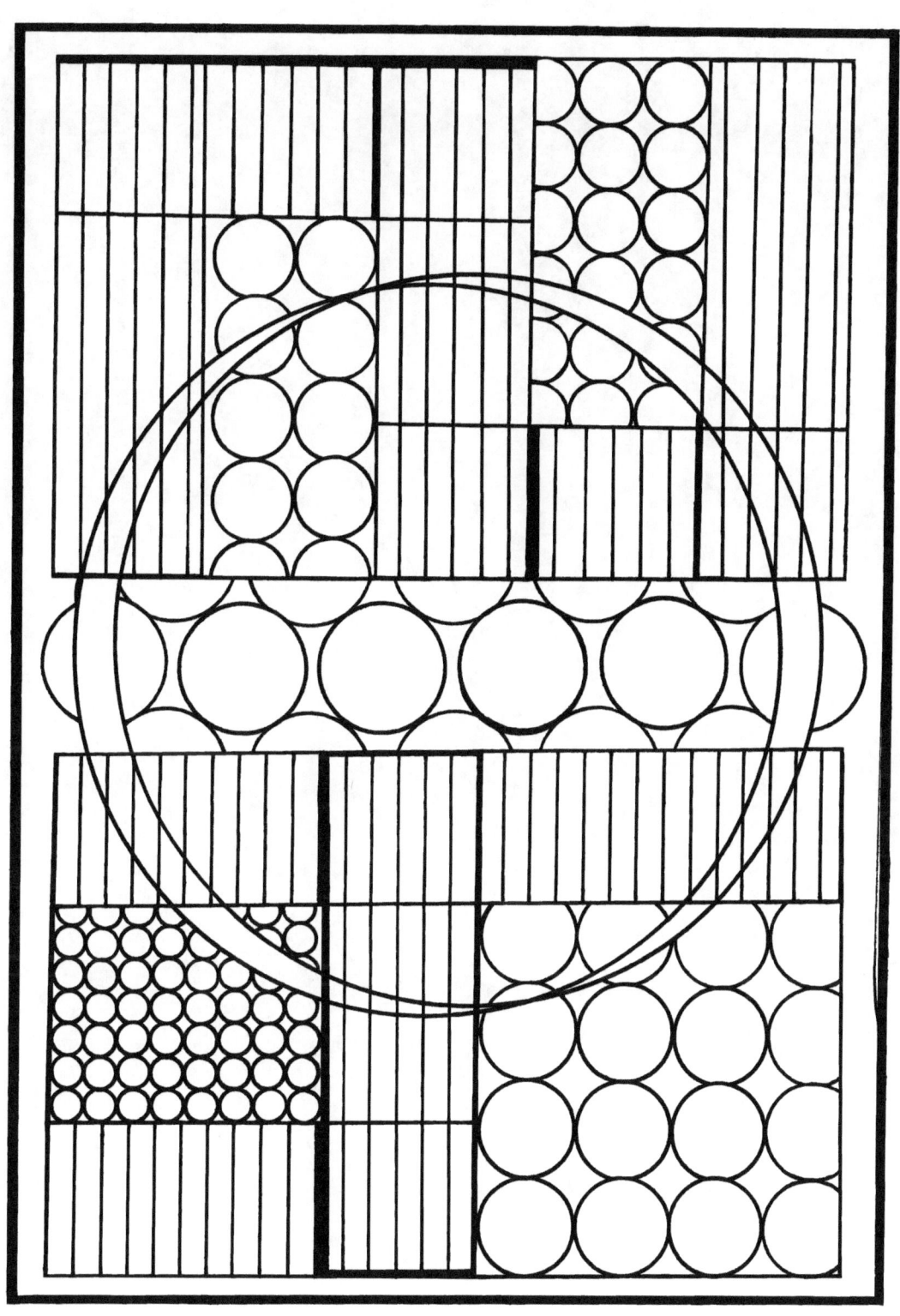

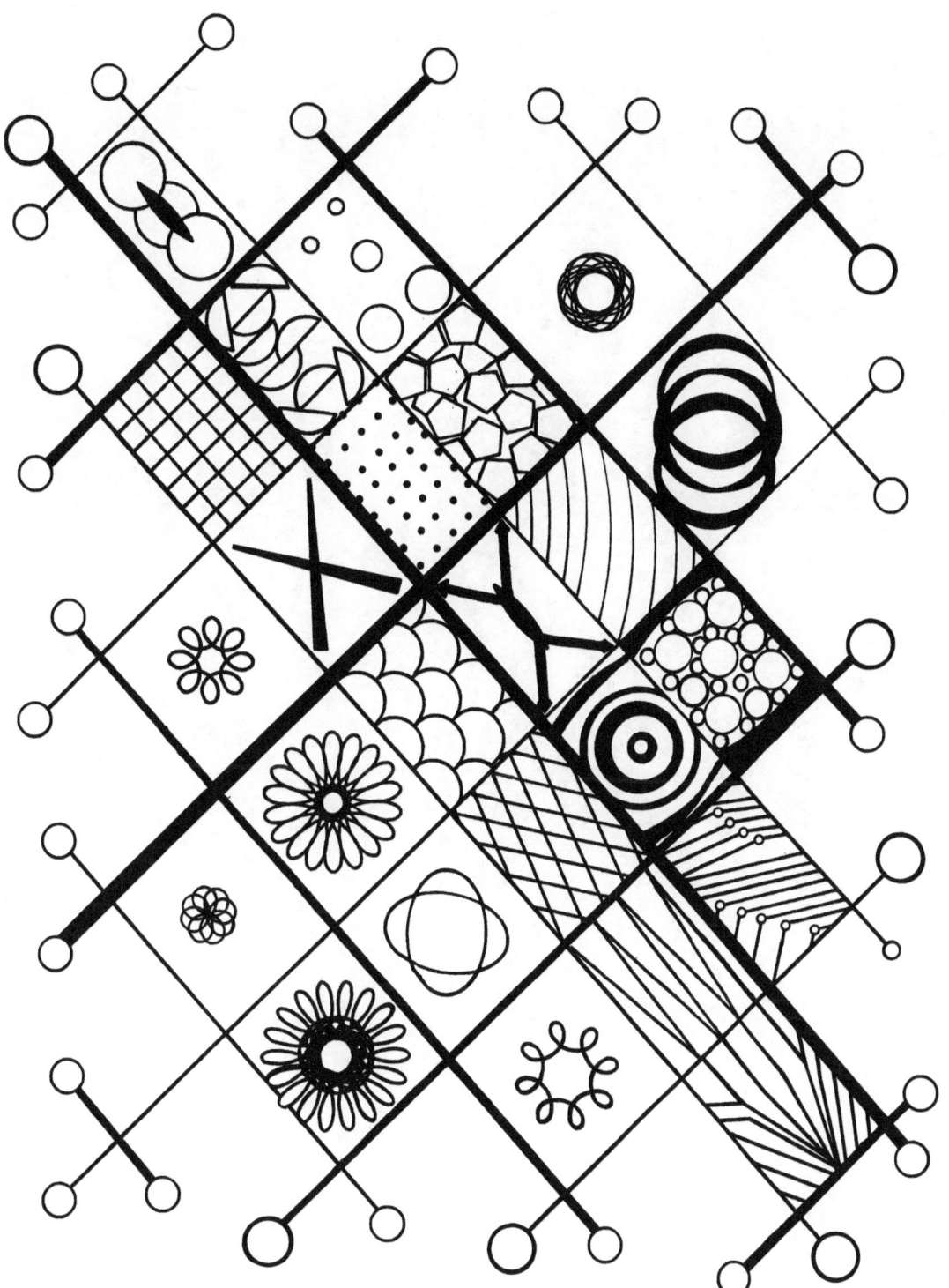

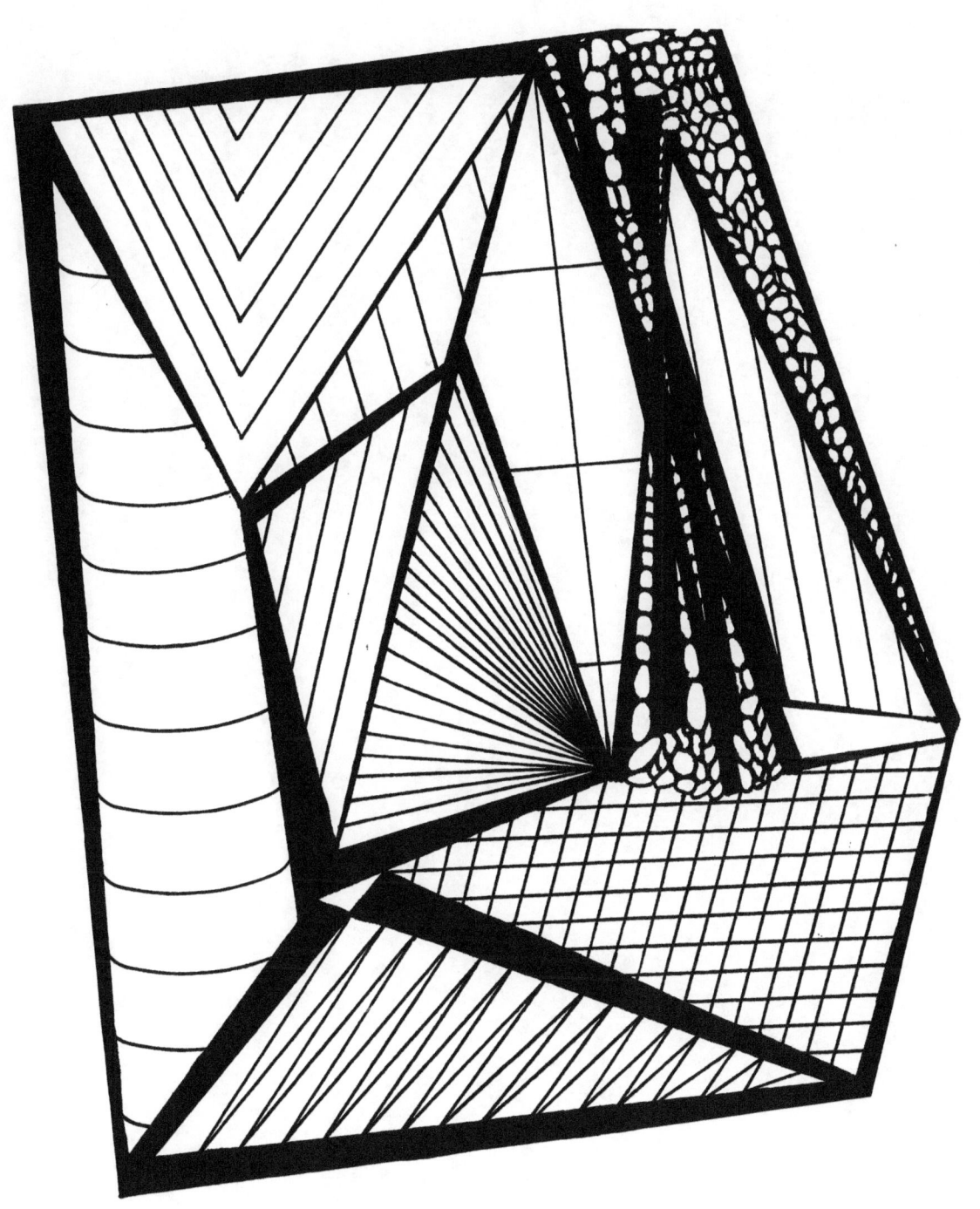

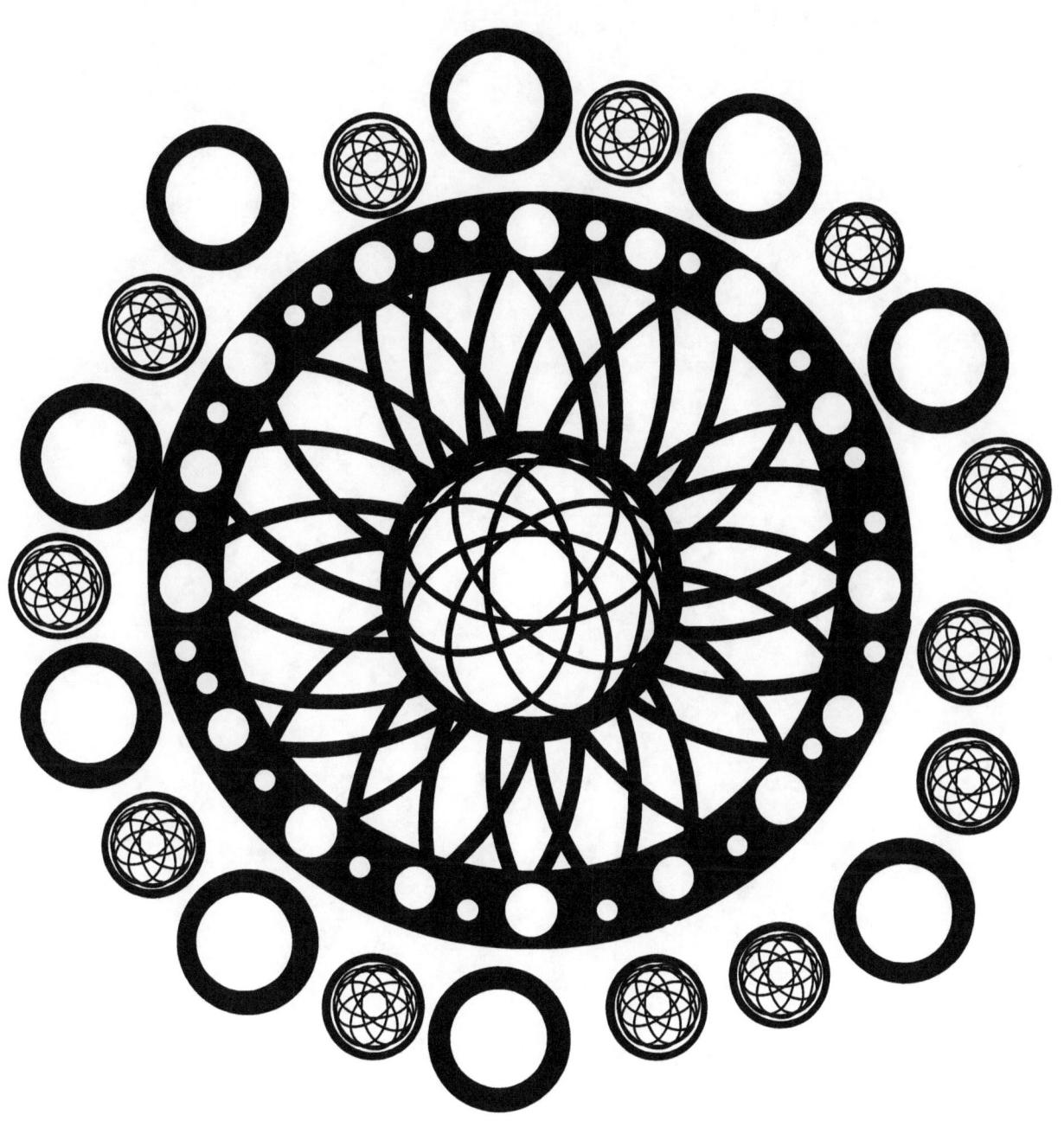

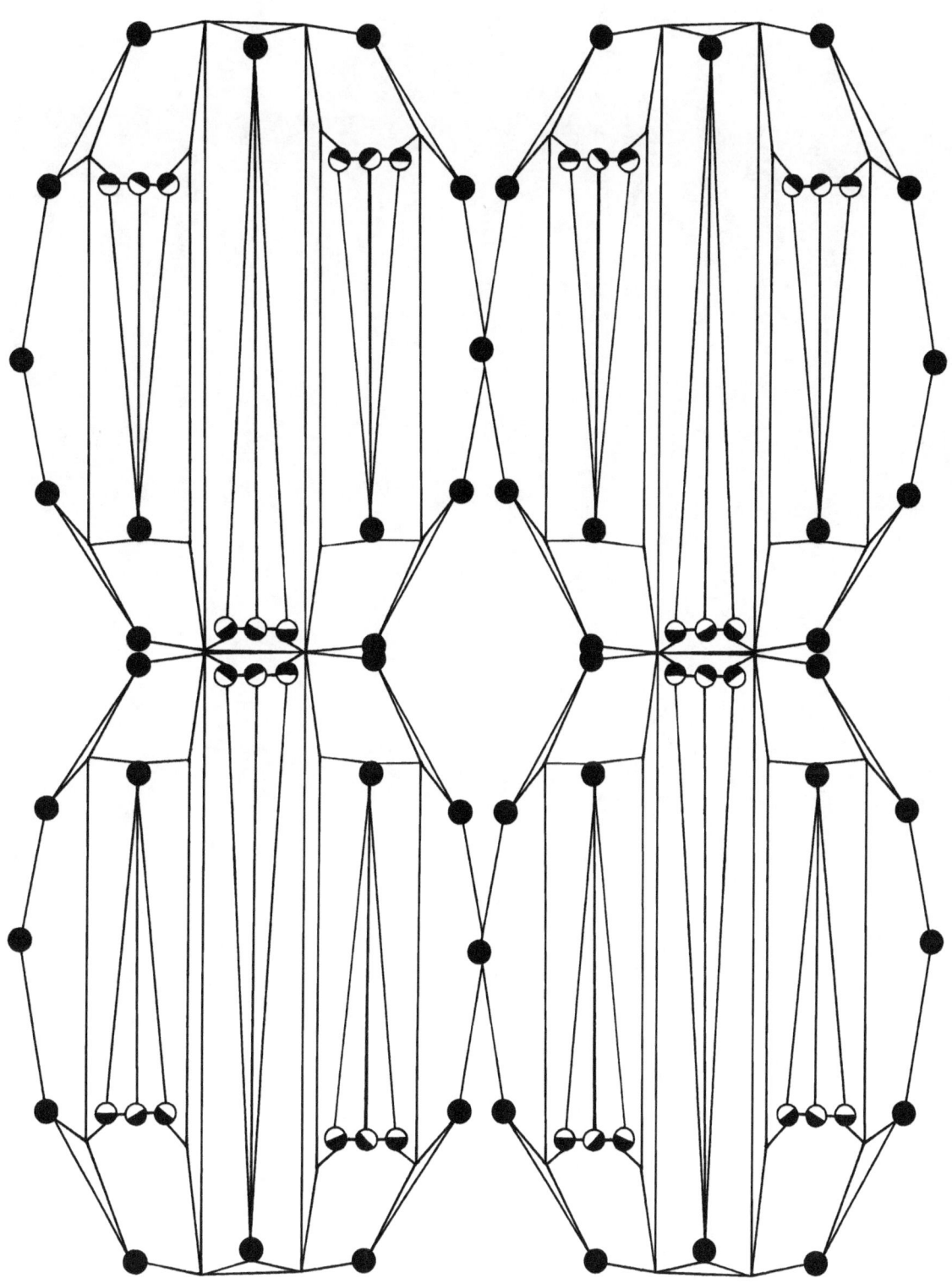

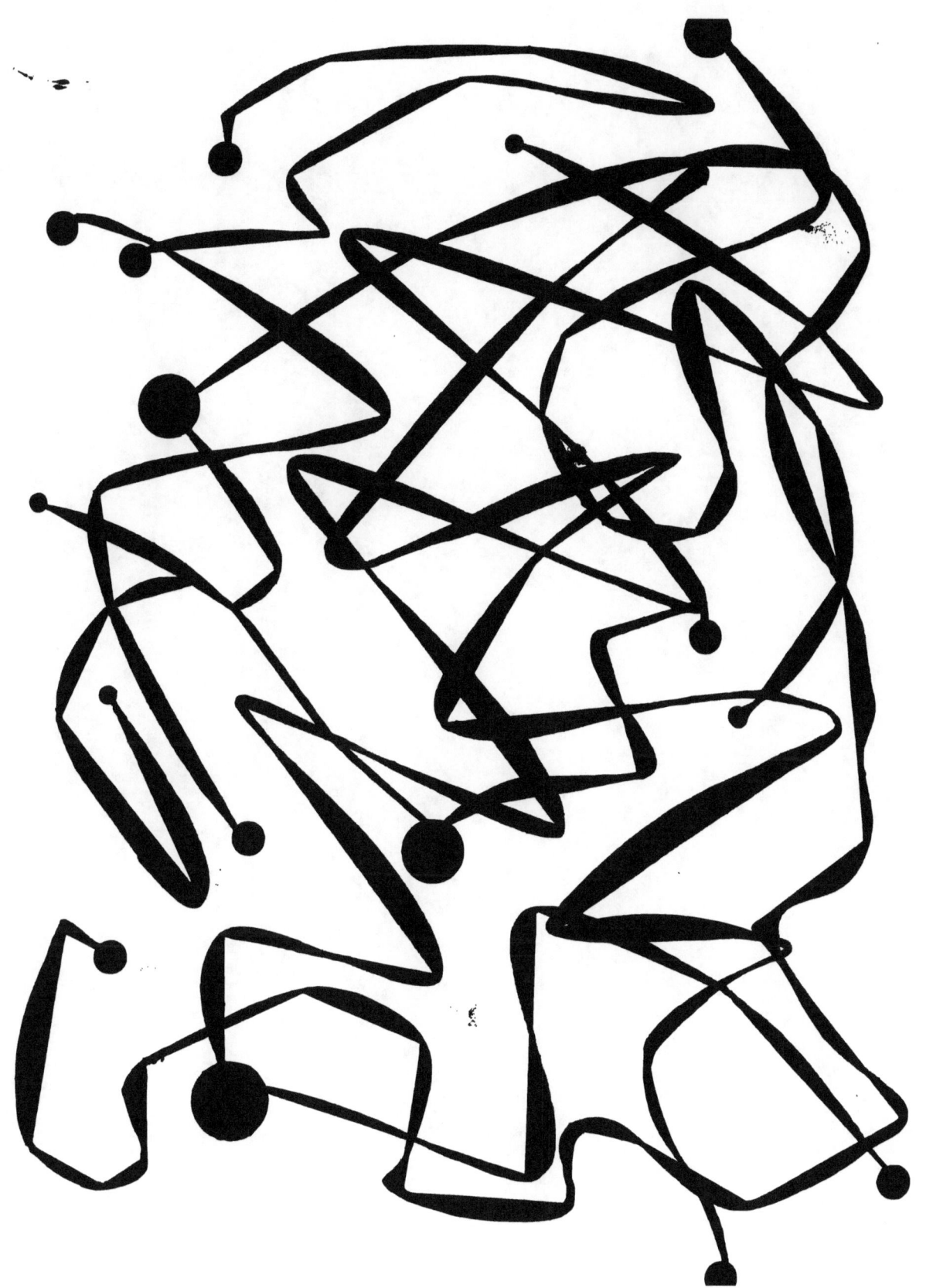

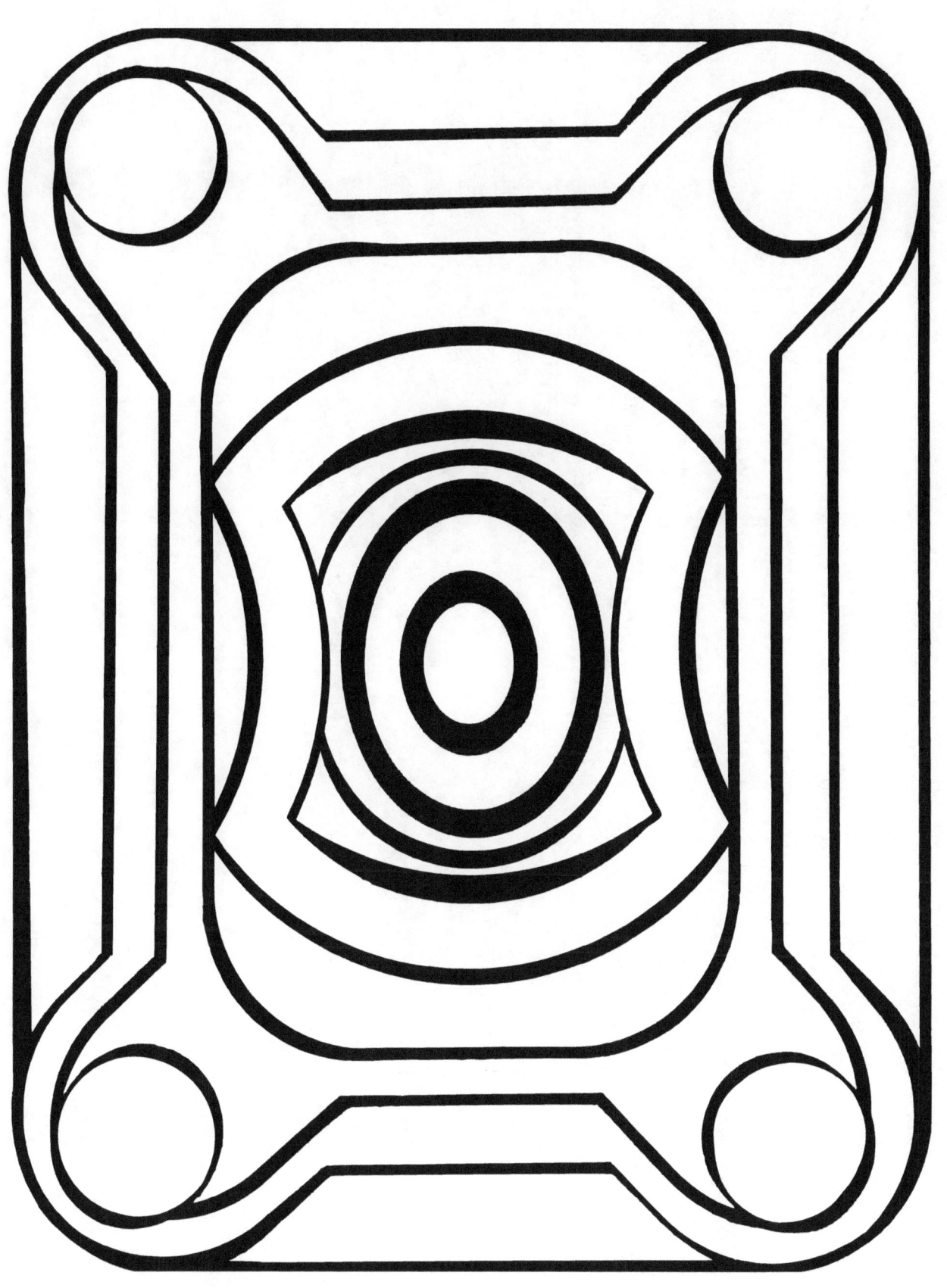

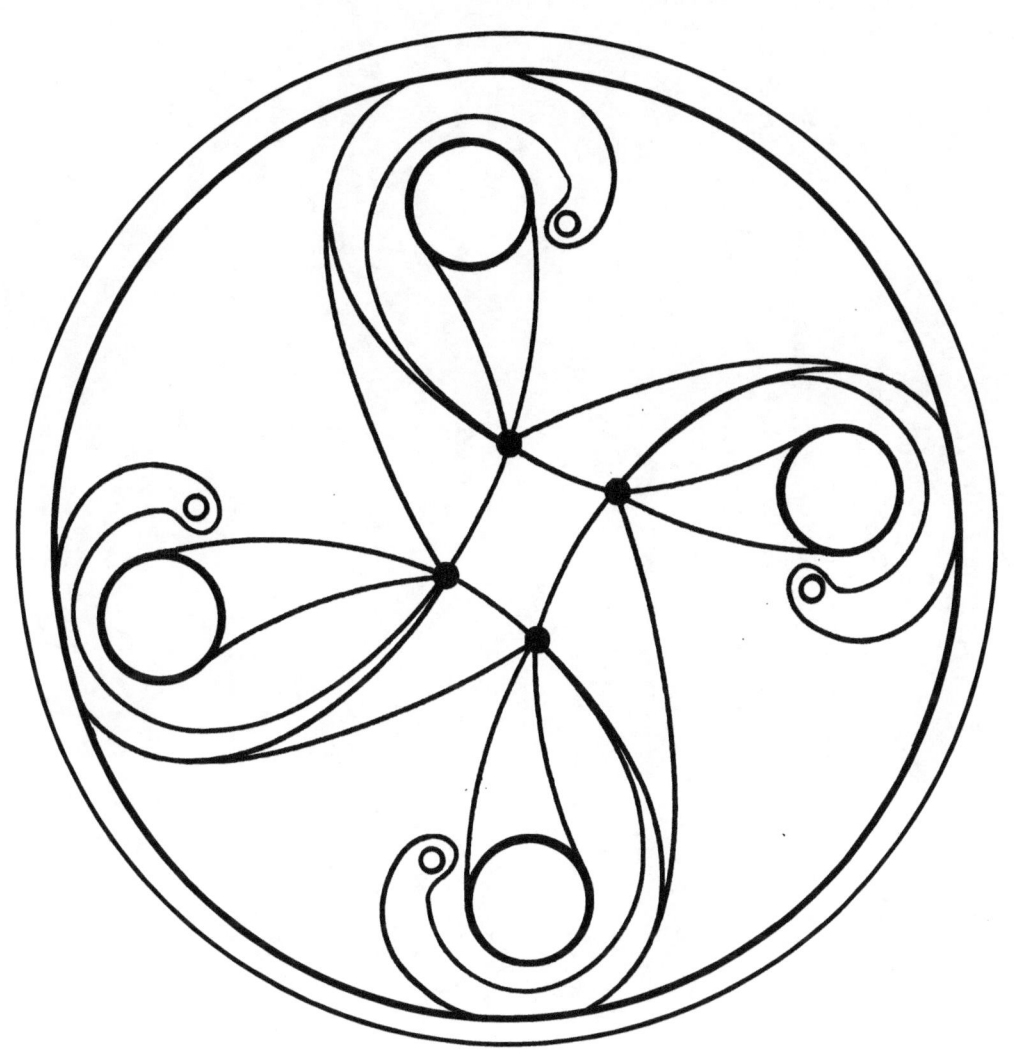

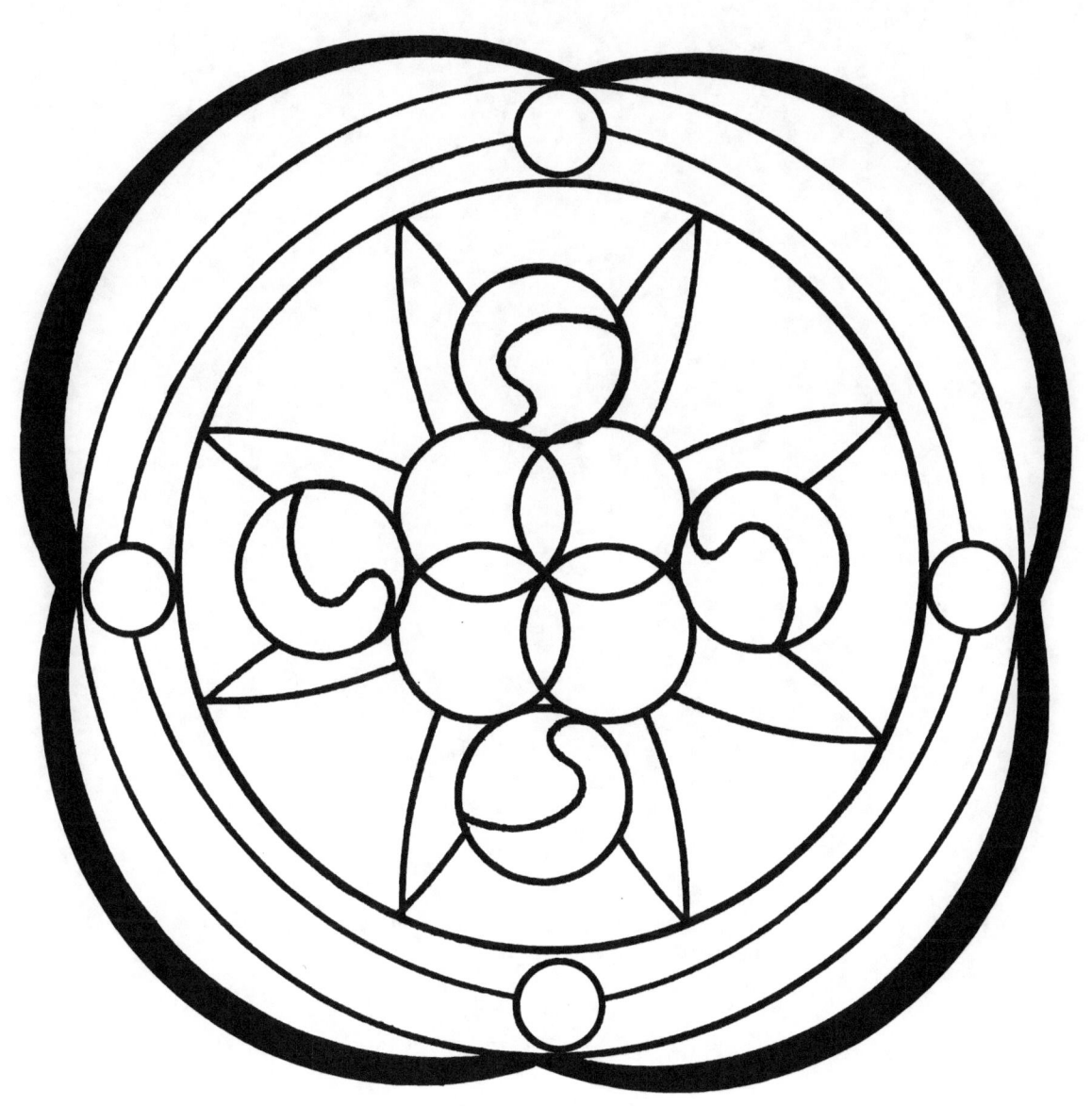

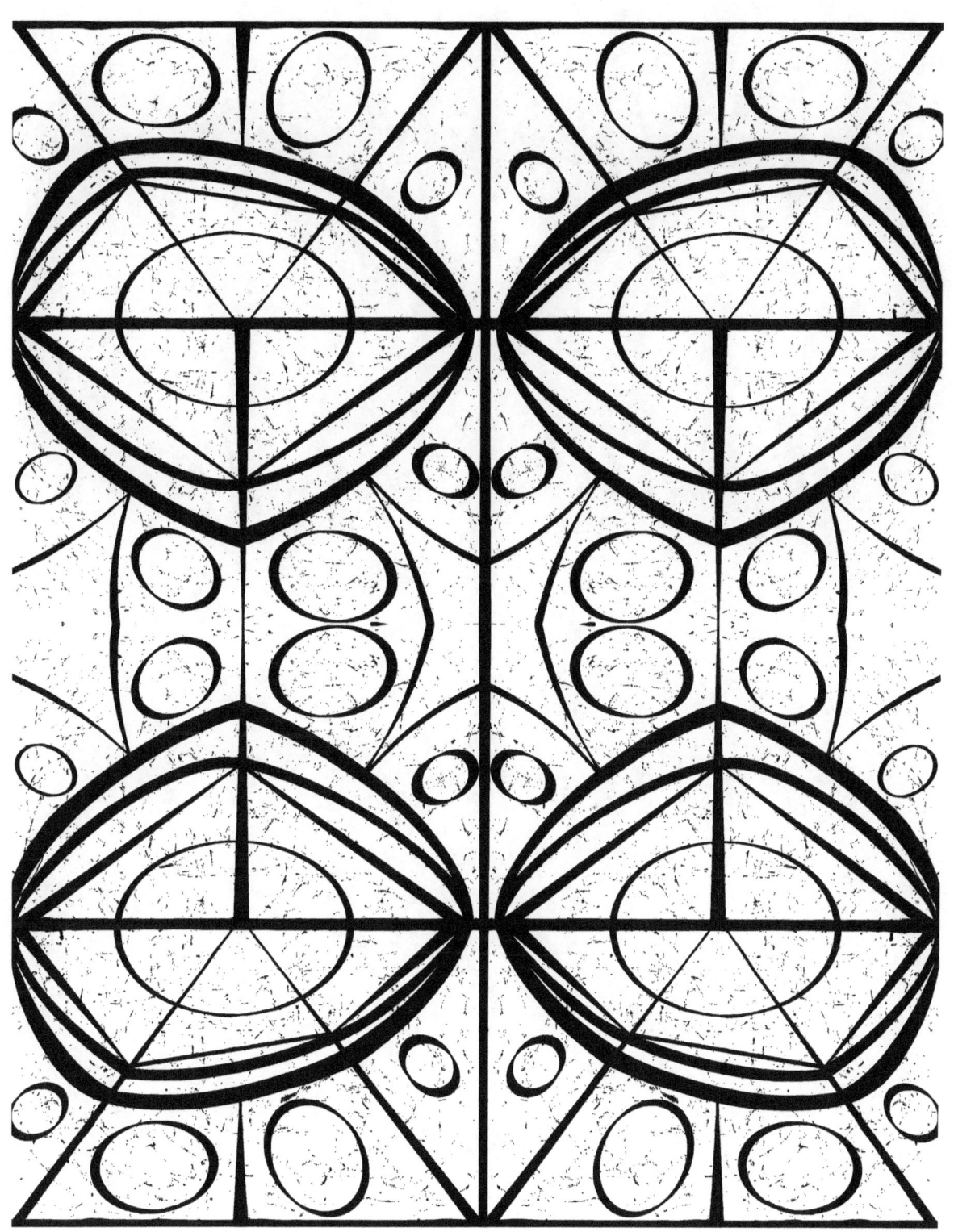

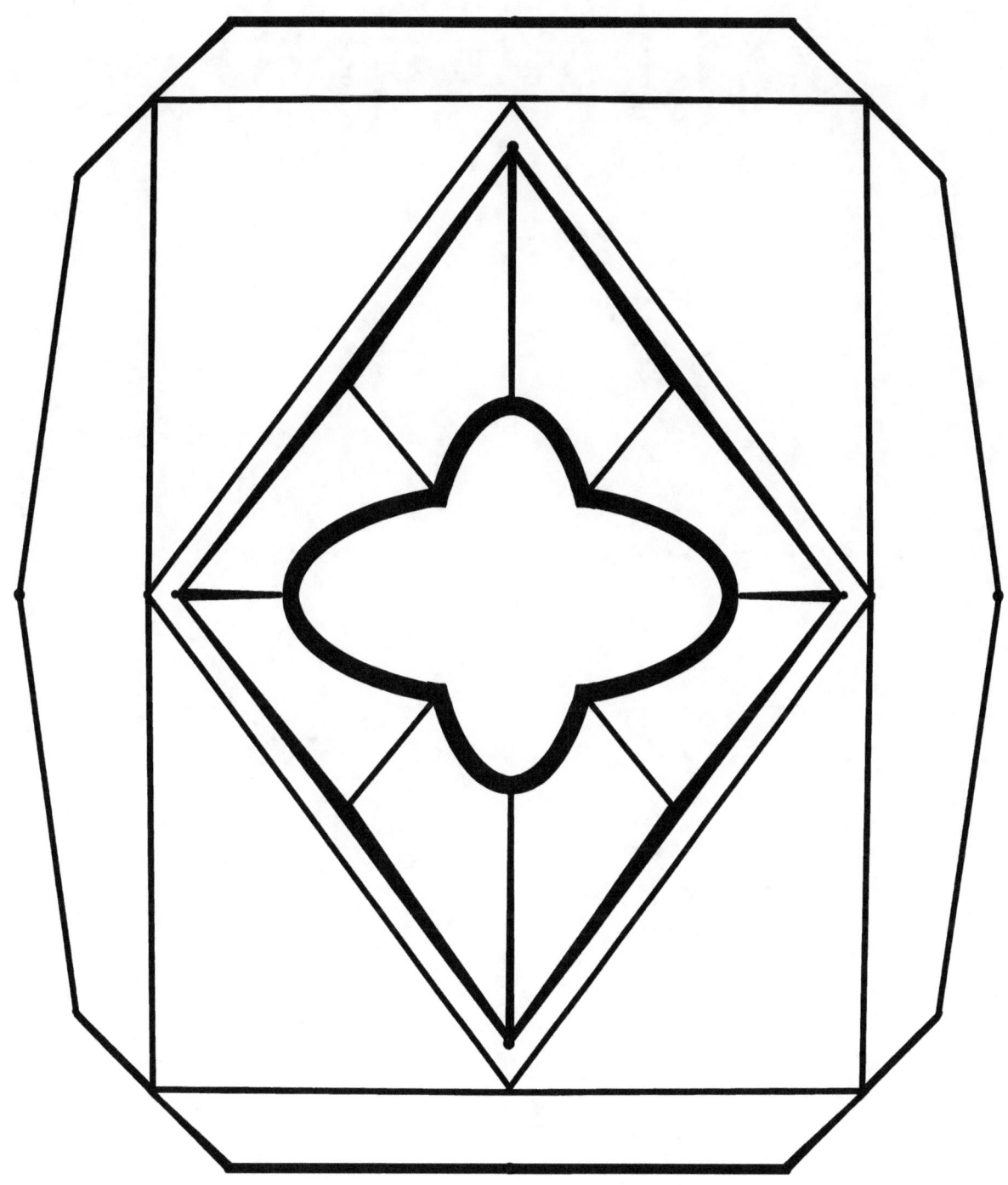

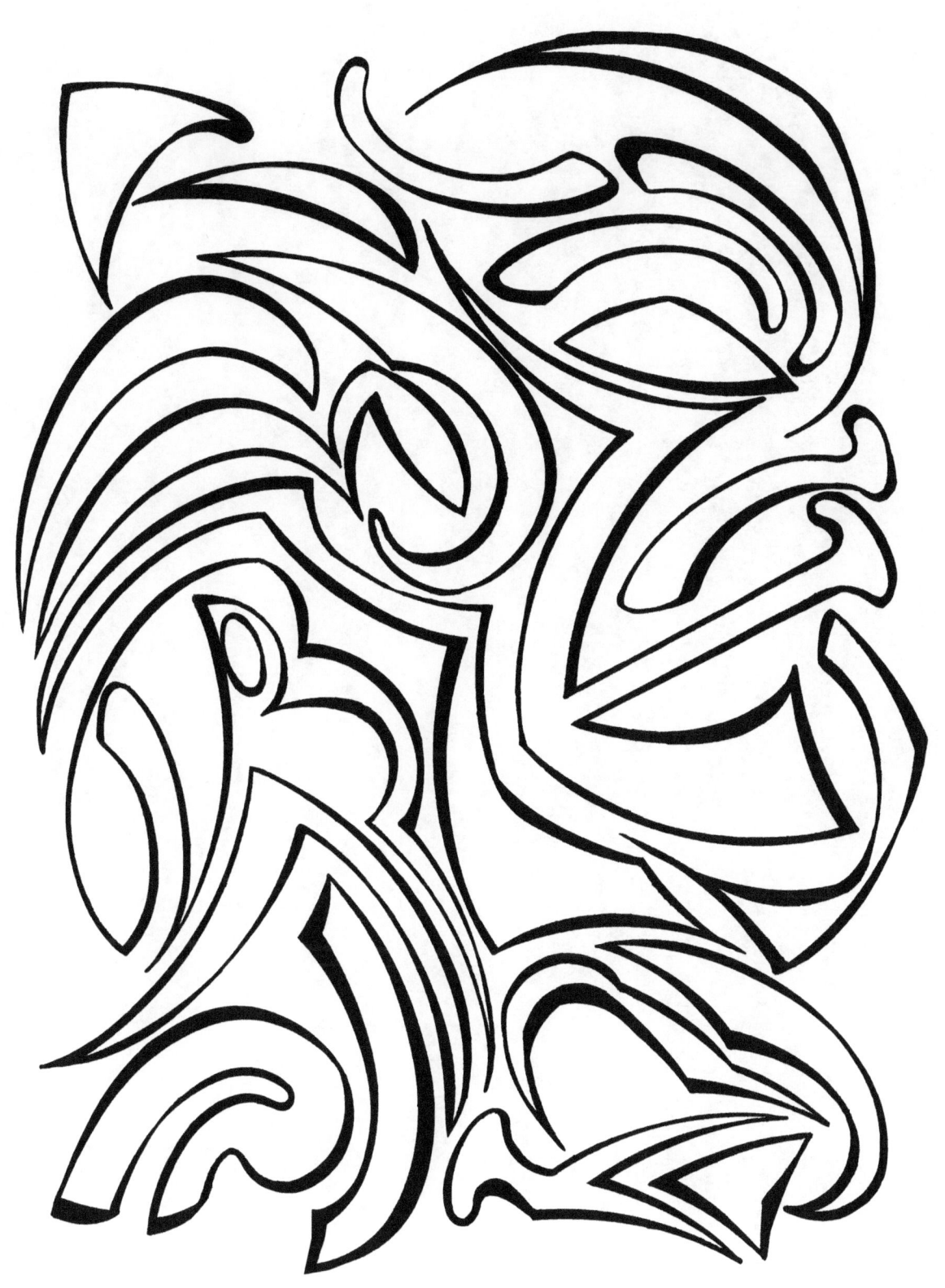

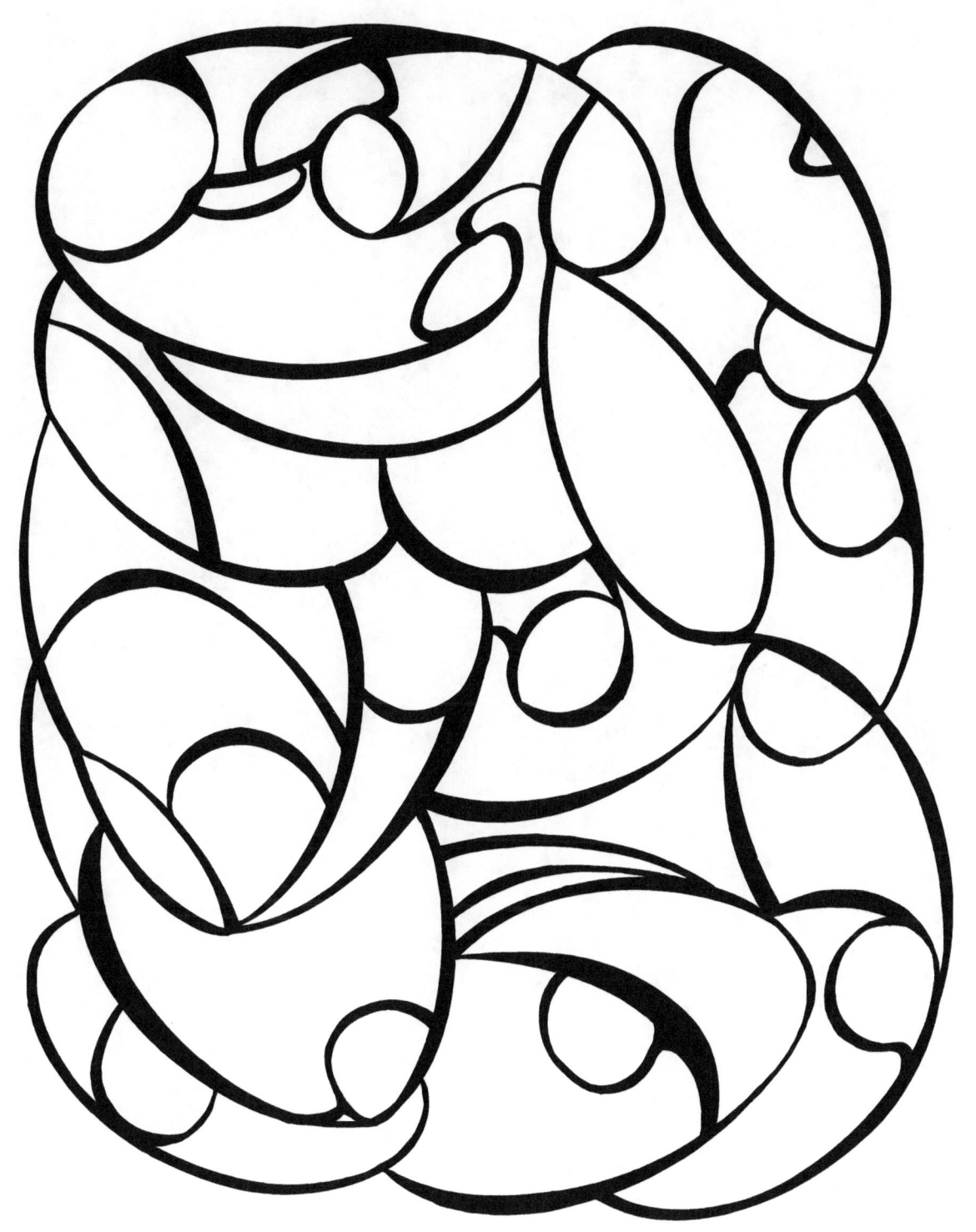

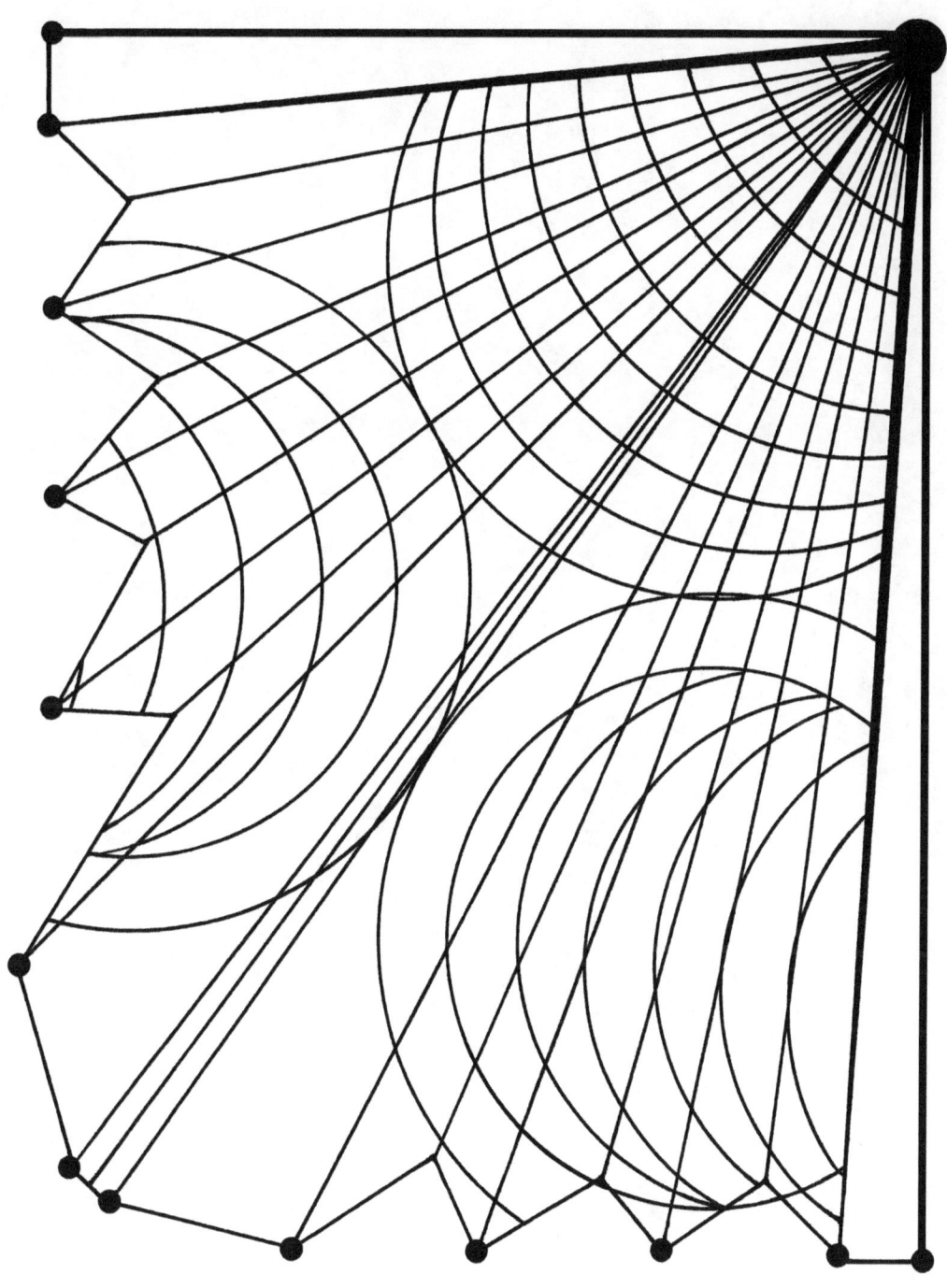

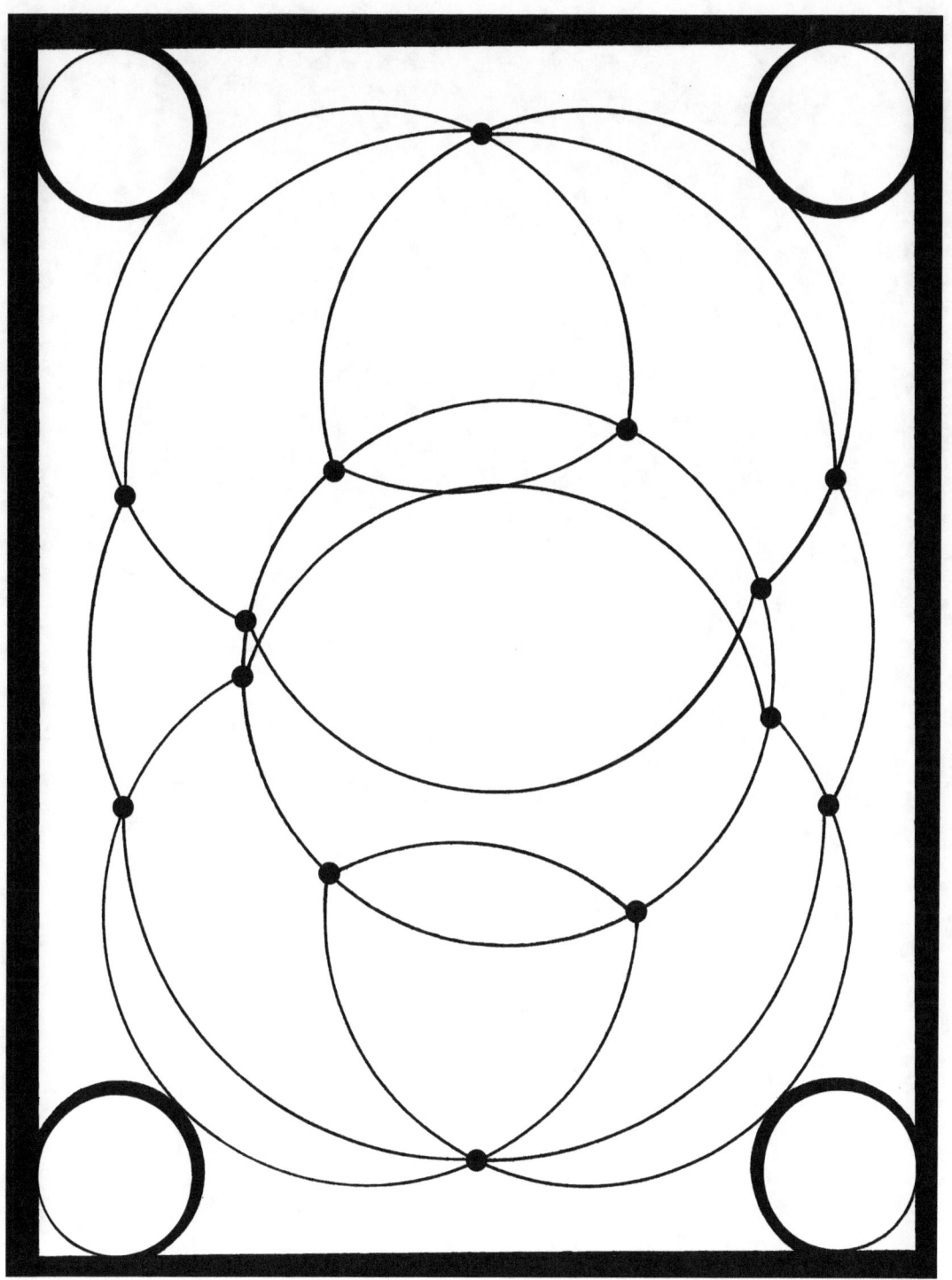

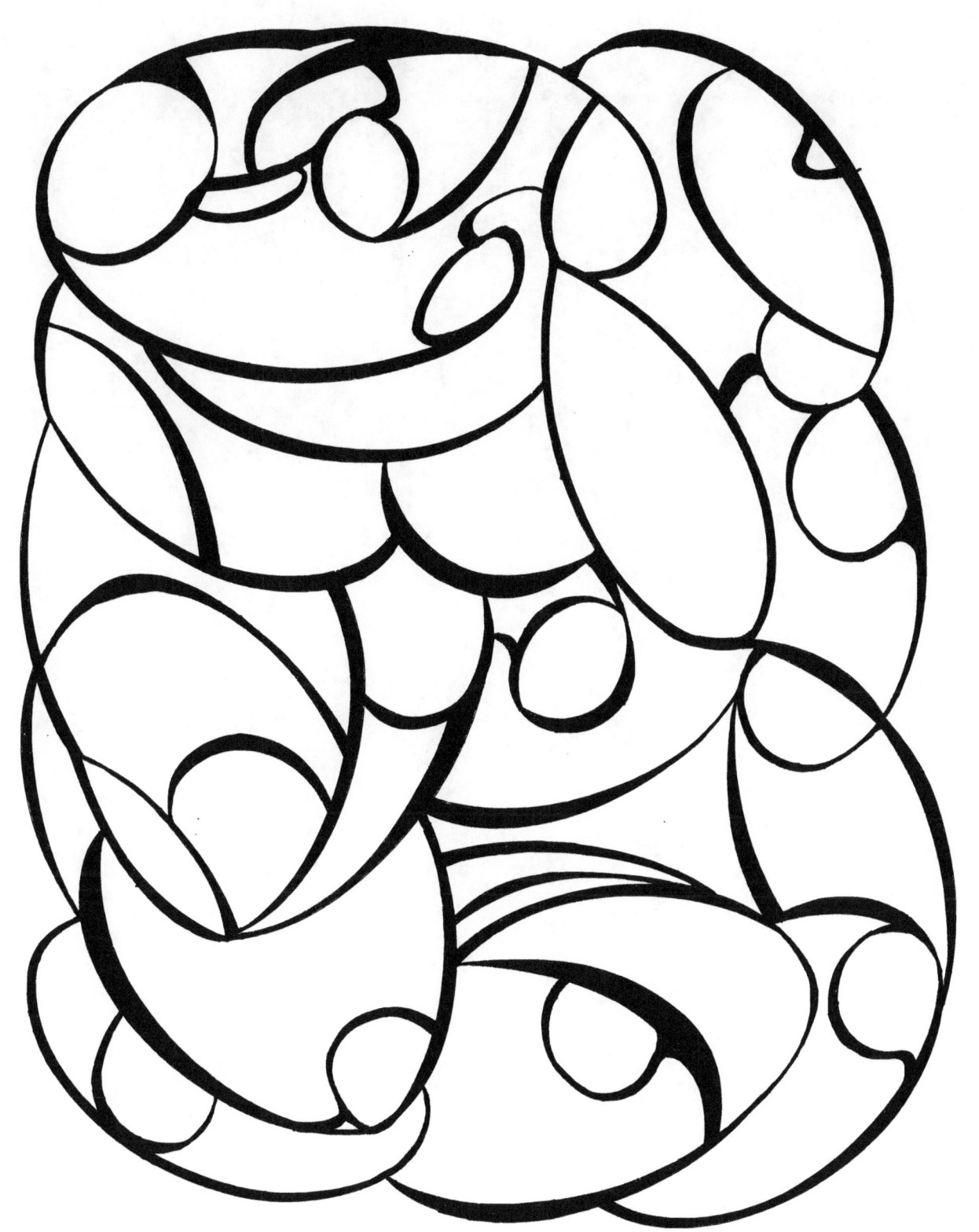

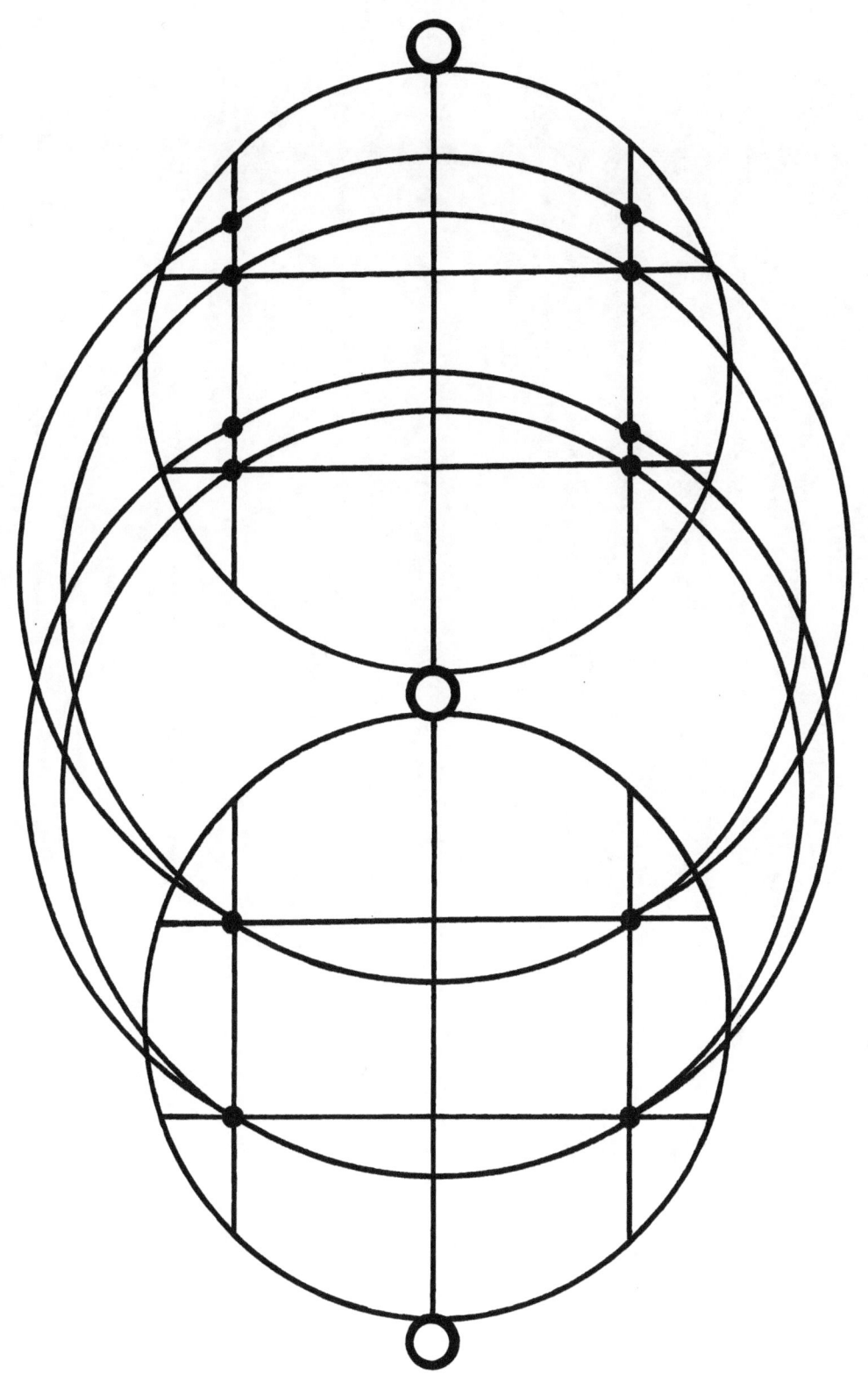

www.ingramcontent.com/pod-product-compliance
Lightning Source LLC
Chambersburg PA
CBHW080709190526
45169CB00006B/2314